WALKIN

Edited by Keiji Takeu
Marco Sammicheli

In partnership with
Triennale Milano and Karimoku

Lars Müller Publishers

JOURNEY OF A SMALL THOUGHT

Walking sticks: I was first drawn to these small, basic too[...] many years ago. I was attracted to them because of wha[...] they represent. They are straightforward and simple. Wh[...] we can imagine the common origins of the walking stick[...] the history of this tool is highly cultural and symbolic, an[...] each piece reflects a persona or shares a legacy with its unique owner.

My first memory of a walking stick is of hiding my grand-pa's stick when I was in kindergarten. I knew how essent[...] it was for him in his daily life, and hiding it was a way of bonding with him in a child's way, simple laughter. As I gr[...] up and started to work in the design industry, I began to observe these fascinating objects out of curiosity. I oft[...] imagined the owners' lives and memories that may be coded on the sticks. When I traveled to different parts o[...] the world, I encountered diverse sticks, and I ended up collecting a few. In recent years, as I have become more involved in furniture design, I have learned to appreciate our way of living with the things around us rather than se[...] ing an object in isolation.

We live in an increasingly elderly society, and I have alwa[...] felt someone should improve the design of walking sticks[...] Many of the common sticks are either designed in a way that is solely medically orientated or aimed at mass production. Either way, they often look like rather poor and discouraging walking companions, which makes n[...] sense for the true purpose of this object. Everyone has a relationship with walking sticks. As children, we may hav[...] memories of our grandparents or parents; and as older adults, we may hold them in our hands or think of needin[...] one soon. It is a universal topic represented by a simple object or gesture. It is fascinating to realize that owning [...] walking stick may at once symbolize authority or be seen as a reason for pity. Depending on the context, a wal[...] ing stick might be seen as a symbol of affluence and leisure, such as with the figure of the *flâneur*; an aestheti[...] statement that is not actually meant for use; or as an essential mobility aid. The status of the object varies de-pending on the context. I felt that in redesigning walking sticks, we might share and express many good ideas an[...] messages about their importance in a symbolic manner. The idea of working on walking sticks grew on me little b[...] little, and I reached the conclusion that it would be even

better if I organized an exhibition to showcase examples of how design can generate new contexts for such an understated yet essential product.

In 2019, I shared this thought with some of my close friends, and I was ready to explore it further. I discussed my ideas with Marco Sammicheli, director of Museo del Design Italiano of Triennale Milano. He was extremely supportive of making this exhibition and the idea was developed to create a show on the museum's ground floor to share the right voices in the right context. I asked seventeen designers I admire to participate in the exhibition. Everyone kindly agreed to submit their design without any second thoughts, and the supportiveness of each designer was palpable at the show.

I shared my thoughts about this project with Mr. Hiroshi Katoh, Executive Vice President of the renowned Japanese wood and furniture manufacturer Karimoku. One day, I was visiting the Karimoku Commons Tokyo showroom, and I bumped into him by chance. We briefly greeted each other, and I naturally shared my idea for the exhibition. He was immediately hooked. He told me right away, "I would like to support your project. I think it is an essential topic for our generation." It was through this partnership that the exhibition "Walking Sticks & Canes" could be presented in a straightforward yet pure manner. It is also through this partnership that this publication was made possible.

Keiji Takeuchi

walking sticks & canes

Alban Le Henry

Alberto Meda

Anker Bak

Cecilie Manz

Chris Liljenberg Halstrøm

Henri Frachon

Hugo Passos

Jasper Morrison

Julie Richoz

Julien Renault

Jun Yasumoto

Keiji Takeuchi

Maddalena Casadei

Marialaura Irvine

Michel Charlot

Pierre Charpin

Ville Kokkonen

Wataru Kumano

sponsored by

karimoku

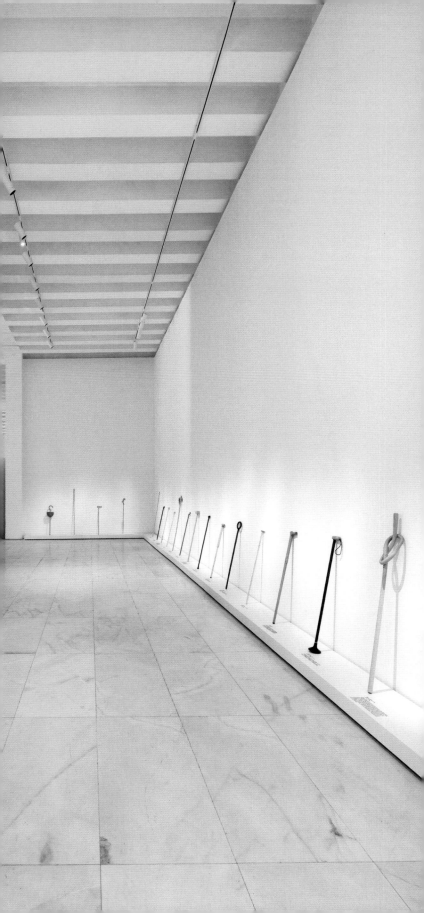

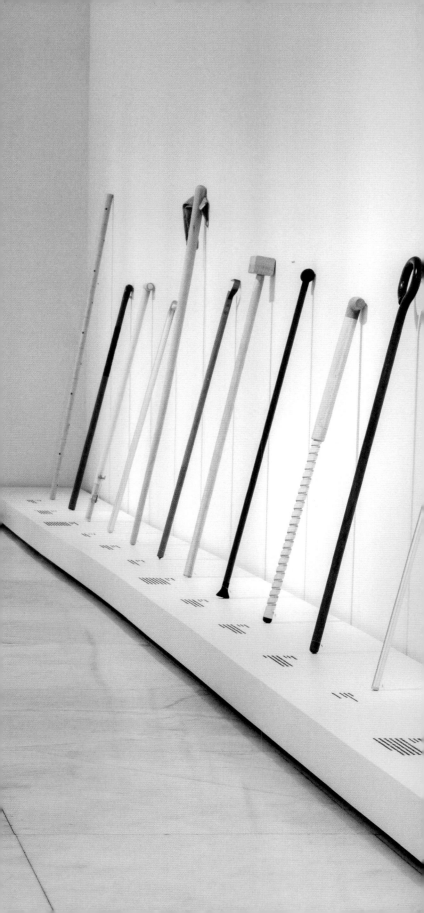

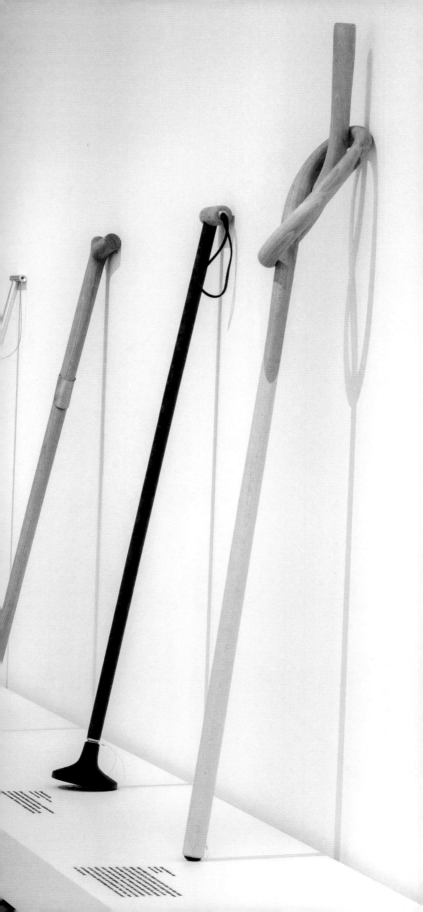

TURNING THE EXTRAORDINARY INTO EVERYDAY CARE

RACING THOUGHTS ON WALKING STICKS

Marco Sammicheli

Scepters of power, unicorns, narwhal tusks, elephant ivory, and gnarled magic wands all belong to the fantastical world that provides the backdrop to the genesis and history of walking sticks. Once regarded as precious objects and always essential supports, walking sticks and canes have been distinguished for millennia by their diverse decorative styles and recurring design elements that reflect and embrace various landscapes, peoples, and traditions.

To provide a framework for the vast array of references that inspire walking sticks, I would like to cite the legend of the rhinoceros depicted by Albrecht Dürer during the Renaissance.

Dürer's rhinoceros is a drawing dated 1515. According to the story, an example of this remarkable animal was sent to the King of Portugal as a gift. The King, in turn, decided to send it as a tribute to Pope Leo X to show his respect. During the journey from Portugal to Rome, the vessel carrying the rhinoceros was caught in a violent storm and shipwrecked. Both the ship and the beast that was caged in the hold ended up at the bottom of the sea somewhere off the coast of the Italian peninsula. As a result, Dürer was asked to create an image of the drowned animal to be included in the records as evidence of the gift. Seeing as he did not have a live model to draw from, the German master had to create an identikit based purely on the accounts of those who had seen the creature or had heard the story second-hand from some lucky survivor.

If one looks closely at the image, it does not actually depict a real animal. Instead, it is an overcharged representation of all the projections of the witnesses that Dürer interviewed, their and his conjectures, and the influence of wood-cut images of fantastical creatures such as griffins and sphinxes that were reproduced in certain printed pamphlets of the time.

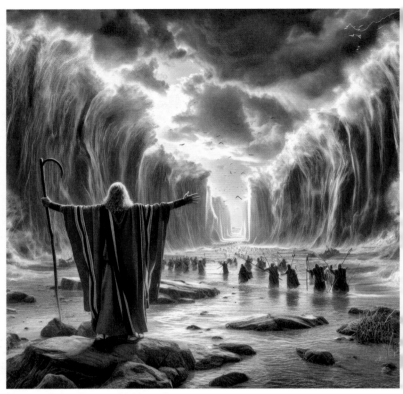

Moses splitting the sea with his staff

Napoleon in exile on St. Helena

Dürer created a woodcut of the creature instead of an engraving, and the relatively crude technique reveals both the actual gaps in information and his attempt to persuade rather than to describe or report.

The animal oscillates between belonging to this world, a concretely observed specimen, and coming from a radically different universe, an imaginary and improbable creature. It is familiar but on the verge of becoming something else, taking on a more fantastical form.

The rhinoceros in the woodcut is covered with plates that look like armor, apparently held together by rivets. It has an extra horn on its back, like the horn on the chest of a knight in ceremonial harness at a tournament. The shell-shaped plate on the hindquarters looks like a skirt or chainmail. The eyes look forward, in contrast with the rigid shell covering the rest of the body. The rhinoceros's eye is the focal point of the image.

The ambiguity of this figure reflects the mutability of forms, not only in nature. We attempt to draw it toward us while simultaneously proclaiming its otherness – a common response, still intact, repeated every day by those who use art and creativity to navigate an ever-changing world. The innovation of archetypes, or even the sketching of a new animal species, has shaped and continues to alter the destiny of form. Even when everything seems imprisoned by a code handed down through the ages, the immutability of form can be contradicted by history.

The story of the walking sticks discussed in this publication is not so different – from those designed by the eighteen contemporary designers invited to Triennale Milano in April 2024 to those found in museums or on display in orthopedic shops near hospitals. They all serve as case studies for examining the relationship between care and vanity, status and function, science and fiction in this specific category of objects.

To explore a brief history and relate it to contemporary issues, as demonstrated in the exhibition conceived and curated by Keiji Takeuchi, we must take the time to dismantle certain clichés and reconnect the world of design with the concept of personal objects.

It is too easy to mentally and visually associate a walking stick with an elderly population. This is not an exact representation of reality. The use of this device for walking, clearing a path, and providing support has never completely vanished from the realm of functional objects.

Despite its long history – the walking stick has been used for millennia – its popularity today remains relatively low.

The essence of the walking stick is tied to the durability required to perform its specific function. Although its role in enhancing a person's appearance with a stylish detail contributes to its longevity, it remains widely used because it fulfills specific practical needs.

Users often keep their walking sticks hidden because they do not like to be seen using them in public. This is where negative connotation comes into play, even though in social psychology it is classified as a "companion object," like glasses, jewelry, shoes, and hats. The cane is, in fact, a tool that aids its user in the details of daily life, especially when it assists with the challenges of aging, the aftermath of an accident, or the onset of a medical condition that sets the person apart from the standard or typical appearance expected in contemporary society.

We will return to the symbolic power of the walking stick later. Historically and in everyday life, the uses and reactions that this object provokes once it is carried lead the user to a rapid exit from social anonymity. It defines, for better or worse, a distinction, establishing a status that today is more biological and sociocultural than political or economic, as was the case in the past.

Certainly, the axiom of walking stick/elderly person is, in percentage terms, still a majority. However, what keeps the discussion open about how the target age for such an object might vary is precisely the role of design, which redefines the cane's characteristics, functions, and occasions for use.

The walking stick has been a companion throughout human history, involving both genders due to the variety of models available. It also encompasses numerous categories to accommodate different roles and behaviors.

Support, weapon, work tool, game, and sport – the walking stick has embraced a vast array of symbolic meanings throughout history. Some of these have persisted over time, perhaps fading somewhat, while others that seemed to have vanished resurface cyclically due to the recurring nature of customs and traditions.

The various supportive functions of the walking stick cover a wide range of characteristics and needs. Often, through symbols and insignia or through the materials used to make them, they can also express eroticism, esotericism,

religion, authority, popular expression, ethnic affiliation, fashion, magic, and music.

Asclepius, the god of medicine in ancient Greek mythology, is depicted in sculpture with a knotted staff to illustrate the difficulty of practicing medicine. If one were to examine walking sticks in an encyclopedic manner, it might be possible, from a historiographic point of view, to propose a classification based on the professions that have used them for specific purposes. For instance: the entomologist, the gardener, the musician, the beautician, the painter, the tailor, the architect, the writer, the naturalist, the seed and stone merchant, the watchmaker, the magician, the fisherman, the assassin, the priest, the pastor, the king, the hunter, the Pope, the gambler, and the pilgrim. This list is not a product of my imagination but is based on research conducted by some of the most respected experts in the field, such as Edith van der Linden, Sergio Coradeschi, Alfredo Lamberti, Klever Ulrich, David Grant, Edward Hart, Xia Gong, and Ali Hassan. After being featured in significant publications, their research has fueled on-going collecting trends across Europe, Asia and the Americas. This practice has saved walking sticks and canes from oblivion, leading us to reassess them not just as luxurious accessories but as objects that can unleash surprising creative energy.

When put in the hands of designers who redefine its functions, forms, materials, and details – as seen in the exhibition curated by Keiji Takeuchi and documented in this book – one can see how an outdated object can be transformed. It can remain an assistive aid for walking while also becoming a more engaging and versatile accessory for everyday life.

The same thing could happen to walking sticks as happened to glasses – which not only address various optical issues but also contribute significantly to our physical appeal, shaping our personality and public image.

A historical perspective offers a coherent way of understanding the evolution of the walking stick. Notable examples include the staff from the Old Testament, used by Moses to part the Red Sea and lead the Jewish people out of Egypt, as well as the trekking pole used in hiking and the technical aid for the increasingly popular Nordic walking.

So, the walking stick can symbolize vitality and movement – a concept that contrasts starkly with the idea of illness – a sign of willpower rather than resignation.

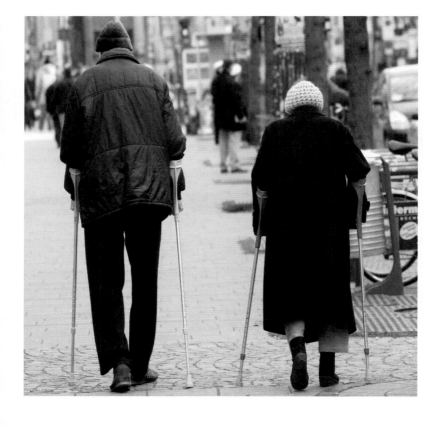

In the Indian creation myth, the *pramantha* is the colossal stick that churns the ocean, creating both the elixir of immortality and the vital fire – elements representing the principle of universal life, which is central to Hinduism. Over time, Moses' miraculous staff has become a symbol of authority in Christianity. Similarly, the walking stick has evolved from a simple *pedum* – the traditional shepherds' crook – into the papal crosier (*pastorale*) and the *baculus*, a shell-adorned staff used by pilgrims, available in souvenir shops along pilgrimage routes throughout Europe and the Mediterranean.

As outlined in this brief discussion, the relationship between objects, history, and tradition – along with the relationship between tools, spaces, and communities – is inherently linked to the concept of a prosthesis: an additional element attached to the body that helps it to perform otherwise impossible actions.

The images of the artist Henri Matisse, who continued working in his atelier into old age while lying in bed or sitting in a wheelchair by attaching a paintbrush to the end of a stick, remind us how important ergonomics are when designing a walking stick.

Another painter, Paul Gauguin, described carved canes as symbols of human solitude that adorn a surface and interact with space through continuous and unpredictable movement. One example is a walking stick he carved himself, which is robust and richly decorated and now housed in the Metropolitan Museum of Art in New York.

The proportions of a walking stick should perfectly match the vital statistics of its user. Height is the key factor, so to take the correct measurements the arm should first be extended down the length of the body. Then, the distance from the ground to the wrist corresponds to the correct length of the stick for the person, possibly with an extra couple of centimeters in case of adjustment.

Walking sticks are generally made up of four parts: the handle, the collar, the shaft, and the ferrule or tip. Situated at the top, the handle is the main and most prominent part. Its detailed decoration conveys status through symbols with clear meanings and messages. Then there is the collar which covers the joint between the handle and the shaft. Whether it is decorative or just a covering, when the cane is made of modular components the collar is often a structural element. The shaft provides the essential structural support. It typically has a round cross-section, but some walking sticks can also have elliptical or even

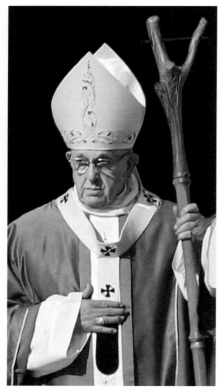

Pope Francis with a bamboo papal ferula

Ethiopian shepherd with a crook

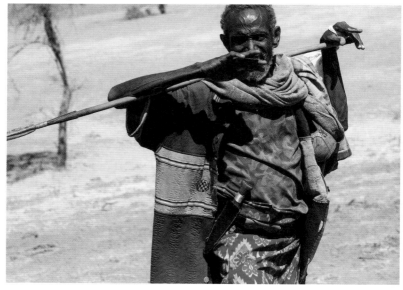

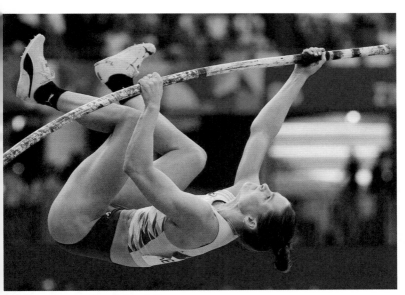

Nina Kennedy wins the gold medal in pole vaulting with a jump of 4.9 meters at the 2024 Paris Olympics

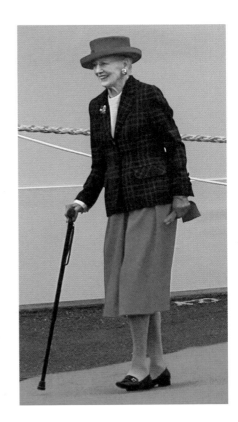

Queen Margrethe II of Denmark with her walking stick

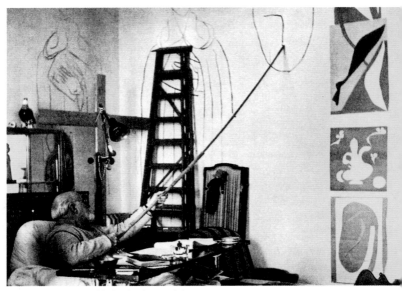

Matisse draws from his bed using a stick

Paul Gauguin's walking stick at the
Metropolitan Museum of Art, New York

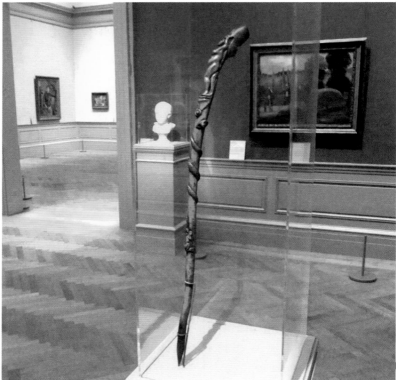

polygonal sections. The shaft can be solid or hollow inside (an essential feature if the cane is designed as a multi-functional tool or needs to be easily transformable). There is no single preferred material for the shaft. It can be made from wood, plant fibers, or materials that are now banned, such as ivory, narwhal tusk, or ox bone. While plastics and metal alloys are the most common, there are also walking sticks made from glass. The tip traditionally serves the same unchanging function: to anchor the walking stick to the type of surface underfoot, depending on the context of use. High-quality walking sticks often allow the tip to be replaced if it wears out or if conditions change with the season and terrain. This ability to replace the tip ensures that the walking stick remains effective and performs well for the user.

The aggressively masculine identity of walking sticks and canes has led commentators to associate them with other objects that share similar semiotic and sociological characteristics. The tie, the conductor's baton, and the pipe are all objects that express a combination of passion, vice, vigor, control, and performance. They share a similar proportional geometry, with the handle or knot serving as the point from which the vertical axis extends during use. This action is what guides the design process. In recent history, various designers and architects have focused on these items due to personal interest, necessity, or as part of their collections. Luis Barragán, Dieter Rams, Roberto Sambonet, Joe Colombo, Andrée Putman, and Nanda Vigo are just a few who have been driven by necessity, the passage of time, collecting, exotic travels, and pleasure to create their designs for objects intended for human use.

This aspect adds another dimension to the reflection on walking sticks, which can be seen as historical, analog, and mechanical precursors to that intimate, multifunctional device that is always within reach: the smartphone, a miniaturized object that accompanies us throughout every aspect of our daily lives. Just as the walking stick, even in its most decorative and accessorized versions, serves its primary function of providing support and balance, so too does this device – an accessorized bridge to the outside world – offer functions that now seem essential only in moments of need: the phone, the flashlight, the heart rate monitor, or the blood pressure gauge. These are the silent lifelines in the sea of silicon and liquid crystals within the cellphone.

The concept of care as prevention – elevated by an aesthetic solution that imbues the function with dignity – distances the user from outdated and uninspired designs that have historically given mobility aids a dreary, hospital-like appearance. The role of contemporary design in addressing these issues is to harness technology, innovative materials, and design culture to create functional objects that do not rely solely on theoretical models.

Like an anthropologist, the designer must turn their attention to aspects of life that have been neglected for too long and update symbols of human solitude. This is akin to the way public transport pictograms often depict a figure with a walking stick, signaling the need to give up a seat to those who use a cane for support.

The designer must be attentive to human needs and, in this case, use their artistic license to create a walking stick that symbolizes dignified existence. For people with disabilities, the walking stick might also serve as a declaration of visibility. The walking stick can reflect the experiences its user holds and offer a perspective on society. This is similar to how iconic figures in film and dance, such as Charlie Chaplin as the Tramp or Fred Astaire, used their canes. The stick has served as an affectation, a distinctive mark, a companion, and a support – a non-speaking actor that, though inanimate, is imbued with life, compassion, and grace.

Today's news shows us figures such as Pope Francis and Queen Margrethe II of Denmark, steadfast with their walking sticks as they meet with heads of state and their followers alike, as well as Paralympic athletes or elderly people navigating city sidewalks. All of them are users of a prosthesis that helps them face the daily challenges of life, encompassing all the nuances of a re-evaluated concept of normalcy.

By metonymy, one type of stick stands apart from all the common categories because it belongs to the realm of the Olympic Games: the pole used for pole vaulting. In the history of the modern Games, Ukrainian pole vaulter Sergey Bubka, who, after his run-up, soars on his pole and clears the bar at 6.14 meters at the Sestriere Stadium in Italy in July 1994, remains an image of glory and athletic ecstasy, where the sport and its equipment enable the athlete to surpass themselves. Most recently, the Australian athlete Nina Kennedy secured the gold medal in pole vaulting at the 2024 Paris Olympics. The big jump using a long stick, or rather the pole vault, continues to symbolize human achievement and endless possibilities.

Le flâneur

18 WALKING STICKS

Anker Bak
Maddalena Casadei
Michel Charlot
Pierre Charpin
Henri Frachon
Marialaura Irvine
Ville Kokkonen
Wataru Kumano
Alban Le Henry
Chris Liljenberg Halstrøm
Cecilie Manz
Alberto Meda
Jasper Morrison
Hugo Passos
Julien Renault
Julie Richoz
Keiji Takeuchi
Jun Yasumoto

NYTTIG

Anker Bak

Produced by Karimoku
Oak wood, brass, and rubber

I'm constantly learning about new wishes and dreams users have in relation to their furniture and aids. After working with assistive furniture for more than a decade, I began to realize that a very common problem for the elderly and people with physical disabilities was that they often wished for products that wouldn't make them stand out too much. Accordingly, I focused on creating a cane that would instill a sense of pride in users, allowing them to see and feel its quality without it being flashy. I wanted them to feel that they could blend in seamlessly wherever they went.

I also learned that many cane users found it physically demanding to pick up their canes when they had fallen to the ground. So, I designed a small brass attachment for the cane, which I named *Snedig* – Danish for "clever" or "crafty". It can be easily flipped out to hang the cane on the edge of a table or chair, freeing up both the mind and hands.

The name *Nyttig* means "useful" in Danish – something indispensable. I found this fitting because of the quiet pride, sensibility, and focus on functionality throughout the design. Nyttig is part of my series of assistive furniture designed to be more democratic and to meet the real needs of real people, all guided by my philosophy: Dignity Design.

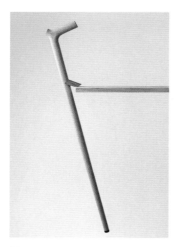

Anker Bak is a Danish cabinetmaker and furniture designer who combines Danish tradition and craftsmanship with innovative and empathetic human designs. He has been the recipient of the Wegner Prize, the Finn Juhl Prize, and the Danish Cabinetmakers Prize for his holistic approach and contributions to design, focusing on people and their needs. Anker has designs and assistive furniture in production with manufacturers across The Nordics, Japan, and Europe. He works based on his design philosophy, Dignity Design.

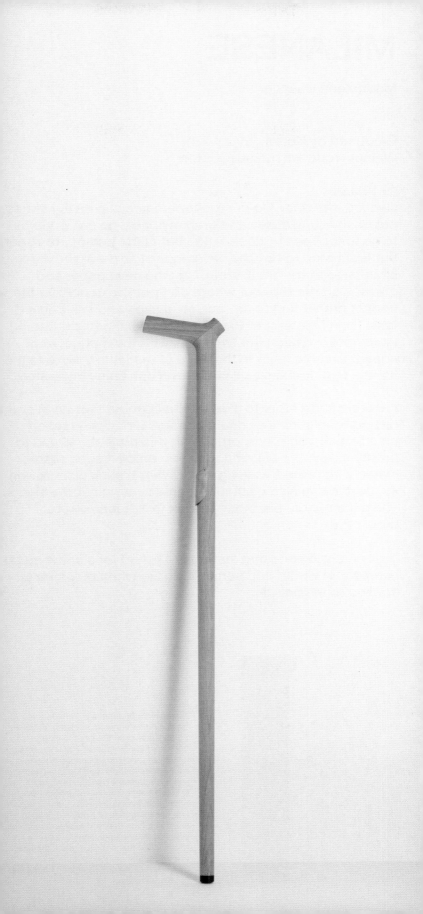

MILANESE

Maddalena Casadei

Produced by Kettal
Walnut wood and stainless steel

"9.10 a.m.
I walk to the door, leave my slippers and slip on my shoes, put on my sunglasses and grab my bag, I go out. I decide to go for coffee at Cucchi's, the bar at the end of the street but first I stop to buy the newspaper. I arrive at the café, sit outside at the small table. I lay the newspaper and glasses on the top, but where do I put the cane? On the floor? I prop it on the top but, ah, it slips and inevitably falls. Then I remember that this last stick I got is different! I separate it, attach the two parts with the magnet and hook the whole thing to the edge of the table thanks to the handle that doubles as a clip. Now I can enjoy my coffee."

I wrote a short story to illustrate my concept for an everyday walking stick that could become a reality if I reach an advanced age. In approaching this project, I aimed to propose a simple solution to the common issues associated with using a walking stick. While a stick can provide support, it can also be cumbersome in certain movements. Thus, the handle becomes a hook for attachment to table tops.

In addition, in choosing materials, I opted for a sheet metal handle that would add some flexibility when pressure is applied to the handle.

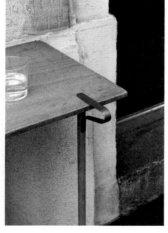

Maddalena Casadei was born in Forlì, Italy. With a degree in architecture from Ferrara, a master's degree in design from the Domus Academy and experience in Sweden and the United States, she was James Irvine's right hand for many years. To date she has her own studio in Milan and is involved in product and exhibition design, as well as art direction. Her design approach is the result of continuous interaction and exchange with all project stakeholders. She prefers chorus to solo. She teaches as a guest professor, at several universities including ECAL University of Art and Design in Lausanne, Switzerland.

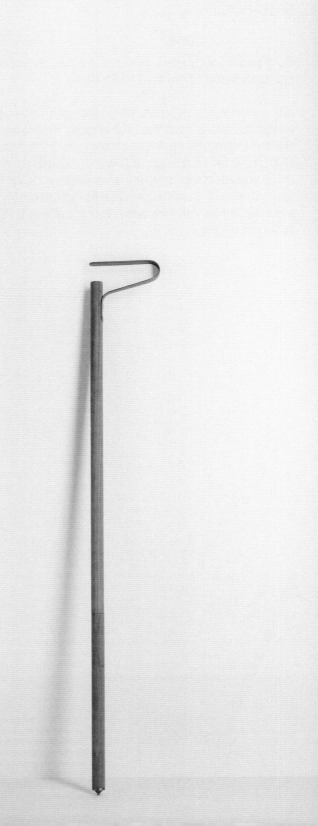

OFF-ROAD

Michel Charlot

Self-produced/special thanks to Sr. Antonio Pinheiro
Carbon fiber, cork, and Stabicane

Off-road is crafted from forged carbon fiber shaft. It features
a comfortable cork handle and an interchangeable stan-
dard Stabicane tip for a prolonged lifespan. In addition to
this, its unique design allows the cane to stand alone.
In case you drop it, you can easily retrieve the cane with
your feet without bending over, adding convenience to
your adventures. The wide base makes this walking stick
truly off-road.

Michel Charlot is a Swiss industrial
designer born in Lausanne (1984). After
graduating from the ECAL University of A
and Design in Lausanne, Switzerland in
2009, he worked for Jasper Morrison Ltd.
In 2011, he set up his own practice, and
began developing products for companies
such as Vitra, Camper, Kettal, and Muji.
From 2013–2022 he taught industrial desig
at ECAL.

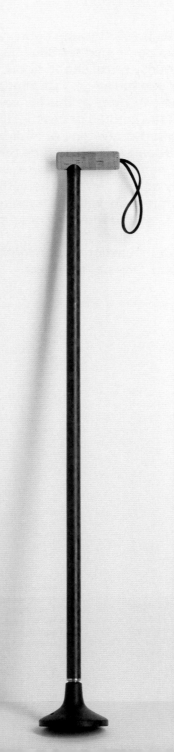

PASSI D'ORO

Pierre Charpin

Self-produced
Brass wire and hazel wood

I wield a staff as I walk through countryside, to find assurance in my step on rugged terrain. I fashion a young, straight, and sturdy hazel shoot, about three centimeters in diameter, or use the sticks I've already cut for this purpose. In the city, none of this is necessary; my legs, my shoes, and the asphalt or cobblestones suffice.
This time, I crafted a new type of staff by patiently winding a thin golden thread around a piece of wood, the companion for my wanderings in dreams, where spatial perception is hazy and uncertain. There, directional shifts are abrupt and unforeseen, without transition, and the light is often elusive, neither truly day nor night.

And who knows, in due course, it might accompany me into the great beyond. One never knows.

Translated from the French by Michael Valinsky

Pierre Charpin is a designer, visual artist, and scenographer who lives and works in Paris and Ivry-sur Seine. Trained as a visual artist, he has since 1990 been dedicated to furniture and object design while continuing his artistic practice. He collaborates with internationally renowned brands such as Alessi, Arita 16/16, Cristallerie Saint-Louis, Danese, Hay, Hermès, Ligne Roset, Manufacture nationale de Sèvres, Träffa Träffa, Tectona, Tornitore Matto, Venini, The Wrong Shop, and Zanotta. His limited edition pieces are mainly edited by the Galerie kreo with whom he has collaborated since 2005. He also works as a scenographer for various museums and for his own exhibitions. His creations have been featured in several publications, including his first monograph *Pierre Charpin* (JRP Ringier, 2014) and *Pierre Charpin avec le dessin* (B42, 2022).

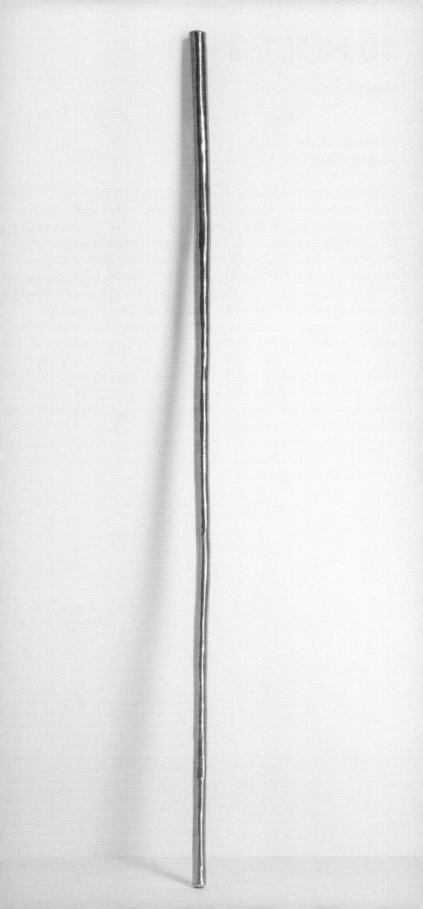

10 HOLES

Henri Frachon

Produced by Karimoku
Maple wood

Man's interventions often begin with a simple hole. Through
their emptiness and universal shape, holes invite us to
look at what is within the material, but also what is around
it – and sometimes what is behind it. Using the interplay
of shadow and light, they create relief and depth. The void
thus enhances the presence of the fullness and allows
matter and air to circulate. For the past five years, I have
been exploring what holes are. I have been digging,
drilling, piercing, molding, and stretching hundreds and
hundreds of holes to better understand their essence.

Inspired by ancient, decorated canes carved from branch-
es, I used precise machining to sculpt a long piece of
maple wood. Ten holes and nine grooves are placed care-
fully throughout the length of the walking stick. The holes
are small enough to appear as black dots and are arranged
in a quincunx to create a rhythm of shadows while we
turn the stick around.

Henri Frachon is a French sculptor and
industrial designer based in Paris. He was
born in 1986 in Corsica and raised in Tahiti.
A former physicist from Claude Bernard
University in Lyon, he worked a few years
in the field of energy before graduating
from ENSCI – les Ateliers in 2019, starting
the same year his on-going research
into holes. He has collaborated with Keiji
Takeuchi and Jun Yasumoto. He was a
laureate of Audi Talents in 2020 and Villa
Noailles in 2021. He launched the *Abstract
Design Manifesto* with Antoine Lecharny
at the Palais de Tokyo in 2021. His sculptur-
al work has notably been exhibited at
Vallauris Picasso Museum, Palais de Tokyo
and Villa Noailles, and is part of French
national collections.

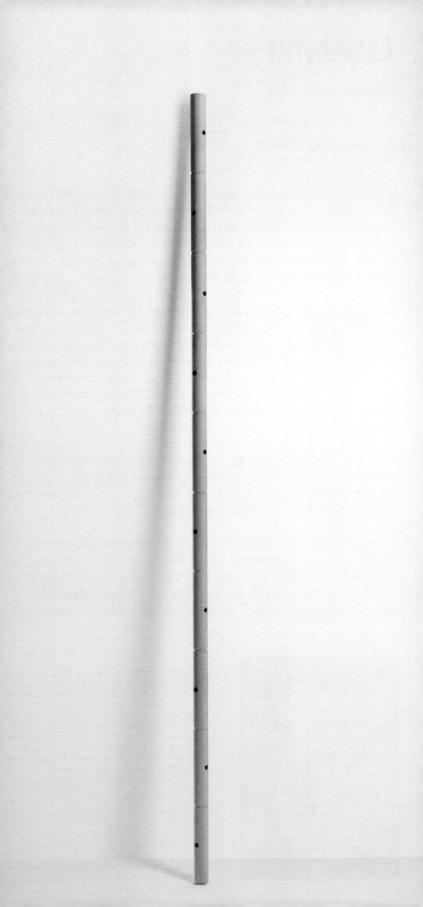

GIANNI

Marialaura Irvine

Produced by Thonet
Beech wood and rubber

My project approach begins with material transformation, balancing creativity and industrial practicality. This was true for "Gianni." Witnessing my elderly parent's daily lives, I saw the importance of a walking stick for their independence. My father, an avid collector of handcrafted walking sticks, inspired this project.

Last year, I bought a walking stick in Japan. It was simple, durable, affordable, and light – a gift for my ninety-one-year-old father, Gianni. When I brought it to him, he adjusted its length to match his height and reattached the rubber tip to prevent slipping. The next day, he attached a small bag to the handle with a knot before heading out to buy the newspaper. He returned with *Il Sole 24 Ore*, cleverly secured to the stick within the bag.

This act made me reflect on the knot as a symbol of bond and love. I envisioned a design accommodating a newspaper or bag, also serving as a hook. The knot aids in finding the right-hand position and height adjustment.

"Gianni" embodies this vision, crafted from two pieces of steam-bent beech wood and a third straight element. Who better to realize such craftsmanship than Thonet? Using a historic mold, we designed the walking stick according to our needs. "Gianni" is dedicated to my father.

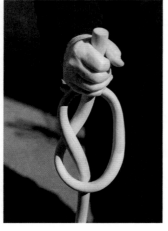

Marialaura Irvine, born in 1972, leads Studio Irvine with a distinct philosophy shaped by her diverse educational background and career. After graduating in architecture in Naples under Riccardo Dalisi, she went on to pursue strategic design at the Politecnico di Milano. Marialaura's design process is driven by extensive research and a profound historical understanding, deliberately avoiding strict adherence to any specific style or typology. She describes her approach as a "radical whisper," emphasizing the transformative power of materiality, encapsulated by the principle of ethics, timelessness and challenges. Her portfolio features collaborations with clients such as Arper, Muji, Thonet, M+, FormaCemento, MDFItalia, and Mattiazzi. Based in Milan, her studio excels in product design, art direction and architecture.

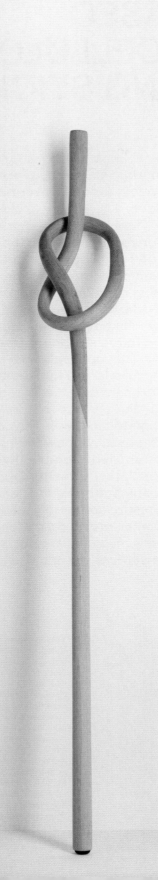

BIO-BASED RIGID CELLULOSE WALKING STICK

Ville Kokkonen

Co-produced with Arkio Industries Ltd. (FI)
Rigid cellulose forming process invented by
Dr. Tiina Härkäsalmi

This is a material-driven approach to the walking stick design brief. The design is based on a 100% bio-based wood pulp profile manufactured by a new processing technique that molds micro fibrillated cellulose (MFC) into hollow tubing. In addition to the material's ecologically conscious character linked to forest industry residues, its properties respond to the structural and sensorial demands of a cane. This rigid cellulose profile can withstand high compressive forces and bending stresses, it is lightweight, and its surface feel is natural, nearly bone-like. When in use and in contact with obstacles, its tone and vibration feel soft to the touch. The cane can be sawn to measure by using basic woodworking tools and an inner thread can be applied in production for flexible adjustment. A stainless-steel, crown-shaped ice spike has been added to the bottom of the cane. It is a standard walking stick accessory commonly used in Nordic countries during winter, providing better traction on icy surfaces. It also has a mechanical pivot which allows users to flip the spike upwards when not in use.

Ville Kokkonen is a Finnish industrial designer. His Swiss-based office centers on a project portfolio that is driven by technological and scientific discovery. Kokkonen's work, which integrates multiple disciplines, spans product design, crafts, material and cultural research, applied sciences and engineering. His key research area is into the sustainable use and processing of natural resources. Ultimately his works often examine and explore healthier living conditions. From 2005–2014, Kokkonen worked with Artek, first running its R&D program and from 2008 onwards as design director of the company. Kokkonen has lectured in numerous institutions and from 2017–2021 held a professorship in furniture design at Aalto University, School of Arts Design and Architecture, Finland.

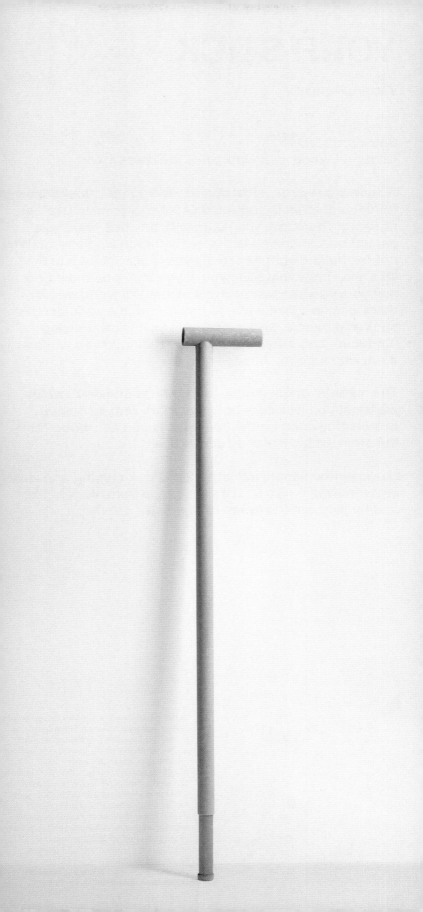

YOUR STICK

Wataru Kumano

Self-produced
Chestnut wood, ash wood, and stainless steel

A cane is a very physical object. Finding the correct answer to "a handle that is comfortable for everyone to use" is not easy. Therefore, I came up with the idea that there should be a shape suited to each person who uses it. Why not try making your handle by yourself? Sculpt it in the size and shape that suits you. If you try it out and it doesn't suit you, you can just sculpt it again. We wondered if there was an optimal way to easily attach and detach the stick and handle, and to securely fix it without using hardware, and arrived at a design that involved joining them with wooden threads.

The material of the handle is Japanese chestnut, which we traditionally use for curving wood, with an animal gelatin glue used for the laminate. I used ash wood for the stem, which is strong and resilient.

I believe that simple activities like wood carving and walking with a cane give us time to escape from modern life and think about the future of humanity.

Wataru Kumano is a product designer based in Nagano, Japan. He studied in Finland from 2001–2008 and worked for British Designer Jasper Morrison after returning to Japan. He established the design office "kumano" in 2011 and has worked on projects internationally for clients including CAMPER, Goldwin, Karimoku, and Nikari. His approach to design is environmental, functional, and responsive to craftsmanship and regional characteristics. In 2021, he was invited to ECAL University of Art and Design, Lausanne, Switzerland, and in the same year, he became an associate professor at Musashino Art University, Japan.

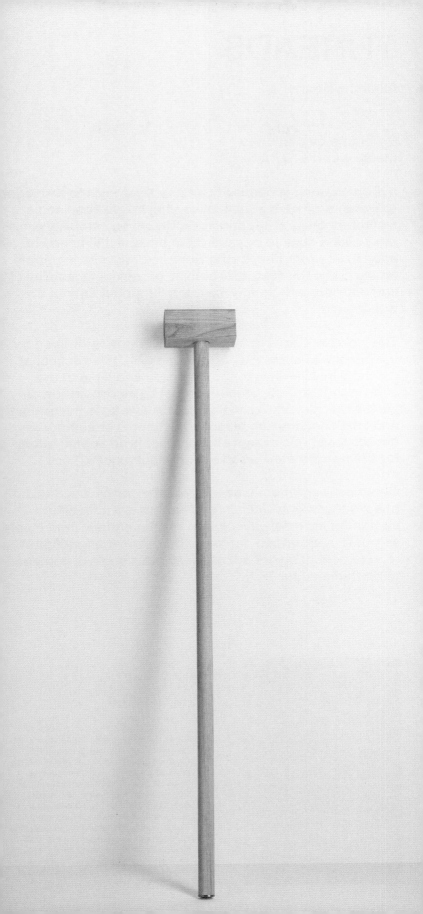

THREADS

Alban Le Henry

Produced by Karimoku
Maple wood and rubber

It is an ergonomic necessity for a walking stick to be height adjustable, ensuring users of varying heights can achieve a comfortable and supportive fit. Height adjustability allows the walking stick to be tailored to the specific needs of each user, promoting better posture and reducing strain on the body. This feature is crucial for providing stability and support, enhancing the overall functionality of the walking aid.

The wooden screw mechanism in Threads is inspired by the threads found in a woodworking vice. This traditional mechanism is known for its precision and ease of use, allowing for smooth adjustments. The incorporation of such a mechanism in a walking stick leverages its reliability and efficiency, making height adjustments straightforward and intuitive. This design choice reflects an appreciation for tried-and-tested woodworking techniques.

Combining ergonomic needs with the screw mechanism of a woodworking vice, Threads offers a practical and straightforward design solution crafted entirely from maple wood. This approach not only addresses the functional requirement of height adjustability but also pays homage to craftsmanship.

Alban Le Henry is a designer trained at ENSCI (Ecole Nationale Supérieure de Création Industrielle) – Les Ateliers. After graduating in 2001, he spent several years assisting the Bouroullec brothers, whose studio was his second school. Starting in 2007, he established his own design studio in Paris and embraced a wide variety of projects, from exhibition scenography and industrial products to objects for galleries. Alban denies having any particular experience, but claims to have "a pragmatic vision or technical sensibility."

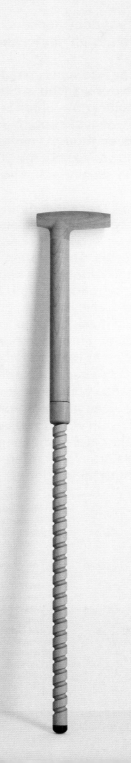

THREADING THE NEEDLE

Chris Liljenberg Halstrøm

Produced by Jonas Lyndby Jensen
Soaped beech wood, linen fabric, and thread

There are two things I depend on to be reasonably happy: walking and embroidering. One is a hobby, the other is work, but I never quite know which is which. "Threading a needle" is the equivalent of starting something, then you are ready to sew. Even though I never regret a single one of my daily morning walks with my dogs, I sometimes lack the motivation while still under the warmth of my duvet.

For my walking stick, I took the idiom of a threaded needle with the needle becoming the walking stick and the thread becoming a wrist band for securing one's grip. My walking stick serves as a motivation to get out on my daily walks and since I am always happier afterwards, the stick becomes dearer to me as well. The walking stick is made of turned and steam-bent beech wood. It has a slight taper and curve as if it wants to go forward. The wrist-band is made from linen fabric with embroidered thread details that both prevent the band from going through the slit in the stick, but also serve as individual markers, so you can personalize your stick and not mistake it for someone else's. You can also embroider new details; maybe from a holiday on which you used the walking stick, or the amount of kilometers you've used it on. The embroidered details are also a reference to threading the needle and getting things done.

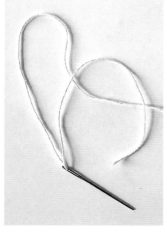

Chris Liljenberg Halstrøm (1977) is a Danish Swedish designer and artist. She lives and works between Copenhagen, Denmark, and Småland, Sweden. She graduated from The Royal Academy, Copenhagen in 2007, having undertaken prior art and textile studies in Stockholm and Berlin. Chris has worked with furniture for commercial companies such as Fritz Hansen and Design Within Reach, but also focuses on experimental exhibition pieces, such as *The Cabinetmakers' Autumn Exhibition* (Danish group with a yearly exhibition of furniture, *Snedkernes Efterårsudstilling*). Chris has exhibited her work at several institutions, including: Designmuseum Denmark, Copenhagen; 21st Century Museum of Contemporary Art, Kanazawa; 21_21 Design Sight, Tokyo; MAK center for Art and Architecture, Los Angeles; Textielmuseum Tillburg.

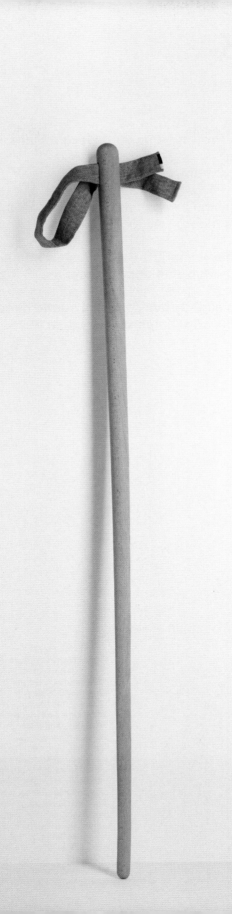

STOK

Cecilie Manz

Produced by Prototypemaker & Cecilie Manz Studio/
Kohei Kojima
Anodized aluminum, cord, and rubber

I wanted to design a super simple, functional stick – a stick
for when I get older.

I found a T-shaped handle best to use, it should be light
and "almost nothing" in appearance.

The handle is slightly oval, giving a subtle direction when
it is held. A thin cord helps keep it close to you.

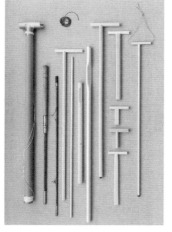

Cecilie Manz was born in Denmark in 1972
She lives and works in Copenhagen.
After graduating from The Royal Danish
Academy of Fine Arts – The School of
Design in 1997, including exchange studies
at the University of Art and Design in
Helsinki, Cecilie Manz founded her own
studio in Copenhagen in 1998. Here,
she designs furniture, tableware, lighting,
and electronics. In addition to her work
with industrial manufactured products, her
experimental prototypes and sculptural
one-offs make up an important part of her
work and approach: I view all my works
as fragments of one big, ongoing story
where the projects are often linked or
related in terms of their ideas, materials,
and aesthetics, across time and function.
My work has always revolved around
simplicity, the process of working toward
a pure, aesthetic and functional object."

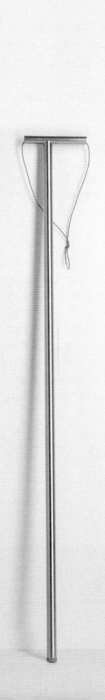

LIGHTWALK

Alberto Meda

Self-produced
Carbon fibre, nylon, and rubber

It is called Lightwalk because it is a walking stick designed to maintain an "elegant balance" during a walk, along a non-tiring path. It is not suitable for going to the mountains. It is also a light object, with a tube made of carbon fiber, an anti-slip rubber foot, and a nylon handle with a shape that allows for a good grip.

The grip is also characterized by an angle greater than 90° with respect to the stem of the stick, an angle that prevents the wrist from "breaking" when you load the stick with your weight because the hand remains in the same direction as the forearm. The technologies used are the filament winding for the stem and 3D printing for both the handle and the rubber tip, contemporary technologies which allow even small series to be created without investments in equipment.

My approach to the project starts from a constructive idea, which must be shaped using the "physicality" of the materials and technologies involved. This constructive idea naturally leads to a consideration of logical connections between the different elements that make up the object, and the materials used set limits and conditions so that, step by step, the shape becomes clear, that is, it is revealed. So, the shape comes naturally; it is not planned. I am not a prisoner of any formal language.

Alberto Meda was born in Tremezzina (CO) in 1945 and studied mechanical engineering at Politecnico di Milano. From 1973, he worked as a technical manager at the interior products brand, Kartell. Then, in 1979, he became a freelance designer, and worked with various prominent companies, including Alfa Romeo Auto, Alias, Alessi, Luceplan, and Olivetti. He was won several design awards, including six Compasso d'Oro, for designs such as the "Meda Chair," introduced by Vitra in 1996. In 2005 he was awarded the "Royal Designer for Industry" by the Royal Society of Arts (RSA), London. From 1983 to 1987, Meda was a lecturer at the Domus Academy in Milan, where he taught industrial technology while also giving lectures and hosting workshops around the world. Since 2016, he has been a member of the Scientific Committee of the Fondazione Politecnico di Milano.

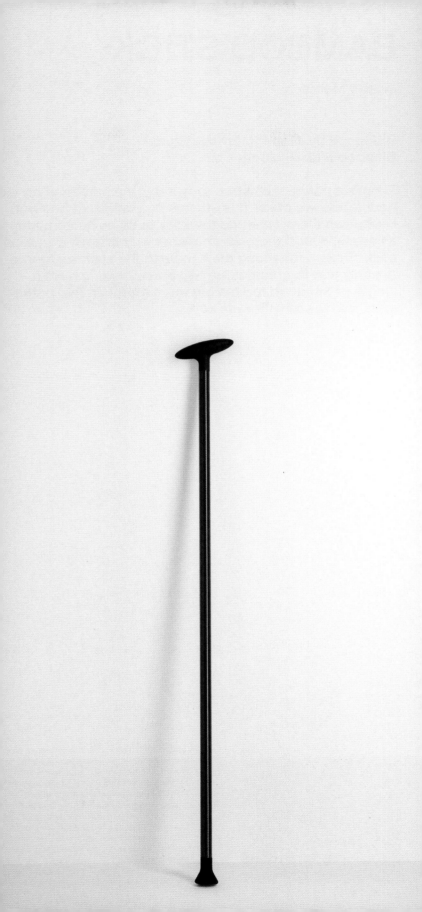

BAMBOO STICK

Jasper Morrison

Produced by Jasper Morrison Studio
Bamboo and wine cork

There's a patch of bamboo growing in the garden of my house, and we made this stick with a length of bamboo I cut down there. I wanted the stick to be as homemade as possible, as if there was no other way to have a walking stick. While connecting the handle to the stick we found the only way to connect the two pieces was to have a length of threaded rod pulling them together. Two of the ends are closed with wine corks.

Jasper Morrison is a British designer, best known for his work in furniture, lighting, electrical products, and tableware. Born in London in 1959, he studied at Kingston Polytechnic, the Royal College of Art, and at Berlin's UdK. In 1986 he opened his Office for Design in London, where he designs furniture and products for a wide range of companies. Jasper has published several books with Lars Müller Publishers, including *A World Without Words*, *The Good Life*, *A Book of Things*, *The Hard Life* and *Super Normal* (with Naoto Fukasawa).

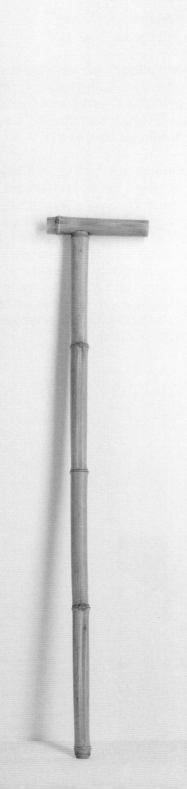

CESTINO

Hugo Passos

Produced by Karimoku
Cherry wood and wicker basket

When the season allows, this walking stick and its practical basket prove handy for going into the garden and picking some fresh vegetables, herbs and fruit for a simple meal or snack. Additionally, it can also be hung from a tree branch while holding a couple of ice-cold beers.

"Another example is the Portuguese-born, Copenhagen-based designer Hugo Passos's 'Cestino' – a cherry wood stick wrapped in a wicker basket – its joyful romanticism more typically associated with youth than the ageing connected with walking sticks. 'I wanted to add something a little bit joyful to growing old,' he says. 'As you get older, you probably would like to have a house with a little back garden – and go out in the morning and pick some herbs or vegetables for lunch while enjoying a bit of sun.'" – from Danielle Demetriou's *Wallpaper** article on the exhibition (June 2024).[1]

1 Danielle Demetriou, "'Design Should be Approachable for Everyone': A Gathering of Walking Sticks And Canes Offers New Ways of Stepping Out," *Wallpaper**, May 11, 2024, https://www.wallpaper.com/design-interiors/marion-vignal-non-profit-genius-loci-exhibitions.

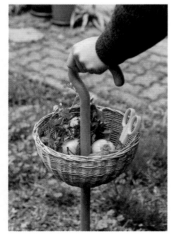

Hugo Passos was born in Portugal and is based in Copenhagen and Porto. He designs familiar objects and furniture that are as pleasing in form as they are in use. His work is driven by a profound fascination with the human scale of everyday objects. Without disregarding the artistic potential of design, Passos stays true to his view that the resulting designs must first and foremost serve their purpose and "do what they are supposed to do." While paying great attention to materials, structure and ergonomics, he has a refined sense of the aesthetics and beauty of the everyday. His work has been produced by companies such as Fredericia, Skagerak, Fritz Hansen, Crane Cookware, Karimoku, Nikari, and Monocle.

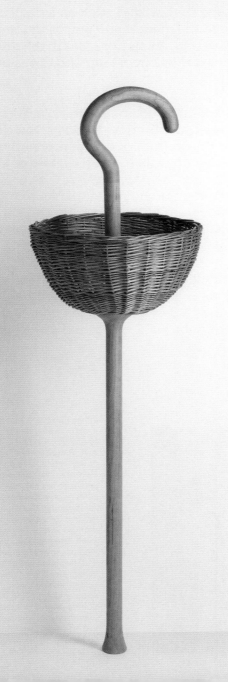

CADORNA

Julien Renault

Produced by Karimoku
Tochi wood and rubber

"Cadorna" is inspired by the shape of sewing head pins that form a complete buckle at their end.

I like to imagine the walking stick as a daily companion for going out to the market and stopping for a coffee while holding a small bag, a scarf or a hat thanks to its handle that naturally extends into a loop and forms an occasional hook.

The name refers to the sculpture "Needle, Thread and Knot" (2000) by Claes Oldenburg and Coosje van Bruggen on Piazzale Cadorna in front of the railway and metro station, the closest stops to walk to the Triennale di Milano.

This project was made possible thanks to Karimoku's expertise. Made from Tochi wood, the cane is constructed in four parts joined by finger joints. This assembly becomes almost invisible thanks to the stain applied to the wood.

Like a continuous line revolving around the hand, Cadorna invites the user to a swinging movement facilitated by the integration of a 34g weight in the cane below the anti-slip pad, making the walk easier and more fluid.

Julien Renault (1985) grew up outside of Paris and attended design schools both in France (ESAD) and in Switzerland (ECAL), two different cultures and approaches to design which have partly shaped Renault's own way of addressing his work. On the one hand artistic, free, and personal, on the other hand systemic, objective, and rational. Based in Brussels since 2009, each of his creations exists not only as an object, but also in its relationship to the environment, demonstrating a strong awareness of the interconnectedness of objects and their surroundings. For several years now, his studio has been growing steadily, thanks to long time collaborations with brands such as Hay, Hem, Karimoku, Kewlox, Mattiazzi, and Nine. His work has been recognized at a number of awards and competitions, and recently he was nominated "Designer of The Year" by Knack Weekend in Belgium.

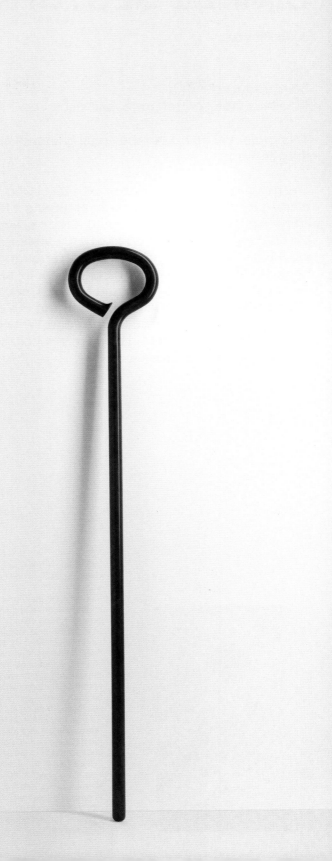

SIMPLE GESTURES

Julie Richoz

Self-produced
Stainless steel, cotton rope, and pen cap

This project is an ode to the small gestures and the charm they embody.

The gesture of picking a flower on a hike. Of taking it home, placing it into a vase. The beauty of turning a fallen branch into a walking stick, maybe tying a rope around. Of putting together materials I find in my atelier. A stainless-steel tube with a very particular form I bought a few years back at Weber Metaux, from their former lovely shop in the heart of the city. A cord from Mokuba, another shop in Paris selling ribbons made in Japan, and the cap of a Copic pen I misuse as a tip for the cane. Writing this makes me realize that this town, in a way, is my field of exploration, my natural landscape.

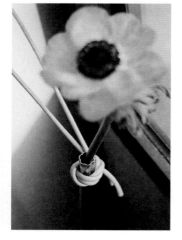

Julie Richoz (1990) is a Swiss-French designer. She set up her eponymous design studio in Paris in 2015, through which she enjoys exploring with curiosity and sensibility the development of her own language through objects. From unique pieces to industrial scale projects, she sees a continuity rather than a difference between these two ways of production. In both cases she is fascinated by the savoir-faire and the passion and precision in handling materials. Her practice ranges from objects, furniture, and lighting to textiles. After graduating from ECAL University of Art and Design, Lausanne (2012), she worked for Pierre Charpin as a project assistant (2013–2015). She was a designer-in-residence at CIRVA Research Center on Art and Glass, France (2013), at Sèvres – Cité de la Céramique, France (2013), and at Casa Wabi, Mexico (2017). She has been the recipient of numerous awards. Since 2017, Richoz has taught industrial design at ECAL University of Art and Design, Lausanne, Switzerland.

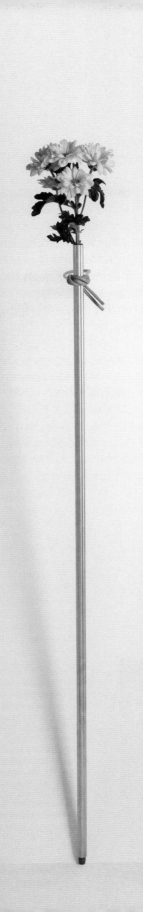

UP

Keiji Takeuchi

Produced by Karimoku
Sakura wood, paper cord, and rubber

I like the way paper cords feel. They are friendly and generous. Applying this material to a walking stick could share a sense of care and provide a nice grip so people can stand up more easily, especially when sitting low. Some existing walking sticks have a horizontal bar in the middle to support people's lifting, but I found a solution that could have been more appealing and better thought through. Using the paper code resolved it in a satisfying manner without unnecessary visual info.

Furthermore, the post gradually gets wider towards the bottom for more stability, while the tapered shape helps keep the hands from sliding down. Then I added a hidden weight at the bottom of the stick that naturally adds supportive swing as people move, hoping to give extra momentum to one's daily stride! Lastly, this walking stick is made of Sakura (Japanese cherry wood), representing Japan's national happiness and crafted by Karimoku.

Keiji Takeuchi was born in Japan and raised in New Zealand. He is now based in Italy, where he runs his design office in Milan. Before establishing his firm in 2015, he studied in Auckland and Paris and worked in Tokyo for the designer Naoto Fukasawa. Takeuchi has created furniture and products for international brands, including Italy's Alessi, De Padova, and Living Divani, Millerknoll in the US, NINE in the UK, Fredericia in Denmark, and Karimoku and aru in Japan. He has won several internationally renowned design awards, including the Monocle Design Award, the Archiproduct Design Award, and the EDIDA Japan Award. During the Milan Design Week 2024, he orchestrated the "Walking Sticks & Canes" exhibition at Triennale Milano. It was Takeuchi's first curated show. *Walking Sticks* is his first publication.

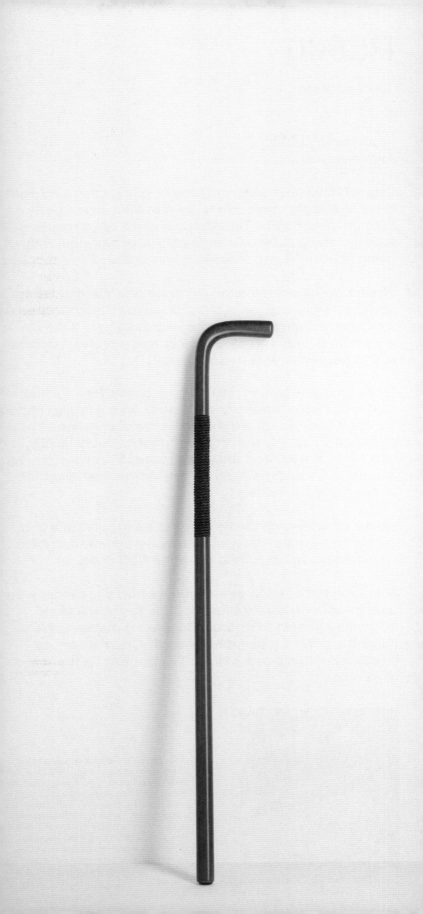

R5000

Jun Yasumoto

Produced by Colos
Aluminum, plastic

Lately, I have been fascinated by how inflecting a straight line into a slight curve can transform the general perception of an object. This subtle change often releases tension, giving a shape a more natural expression, without being necessarily noticeable at first sight.

When Keiji Takeuchi invited me to join the Walking Sticks and Canes project, I was busy designing an outdoor chair for Colos, aiming for a fluid shape using gentle bends in aluminum tubing. The cane project was a perfect opportunity to further explore this approach.

Three thoughts guided my design process. First, I visualized the classic form: a straight stick with a hook-shaped handle. Then, I imagined a slight curve superimposed on this image, aligning with my current obsession. Finally, I decided I should limit the design time to keep the project spontaneous and maintain its freshness without getting bogged down in details.

I focused on finding the precise radius of curvature that oscillates between the assumed curve and the illusion of an inflection, which turned out to be R5000mm.

A walking stick profoundly influences how you perceive the person using it. My experiment explores how a slight curve might affect this perception from a distance. Will it make the person look more relaxed? Could it convey instability or dynamism? Might it even cheer up the stance of its holder?

Jun Yasumoto was born in Tokyo in 1977 to French and Japanese parents and now lives and works in Paris. After graduating from ENSCI-Les Ateliers (Paris) in 2001, he established himself as an independent designer and began collaborating with Jasper Morrison Ltd. in 2002, with whom he has since worked on the development of numerous projects. In parallel, he has developed his independent career, working with clients in Asia, the United States, and Europe.

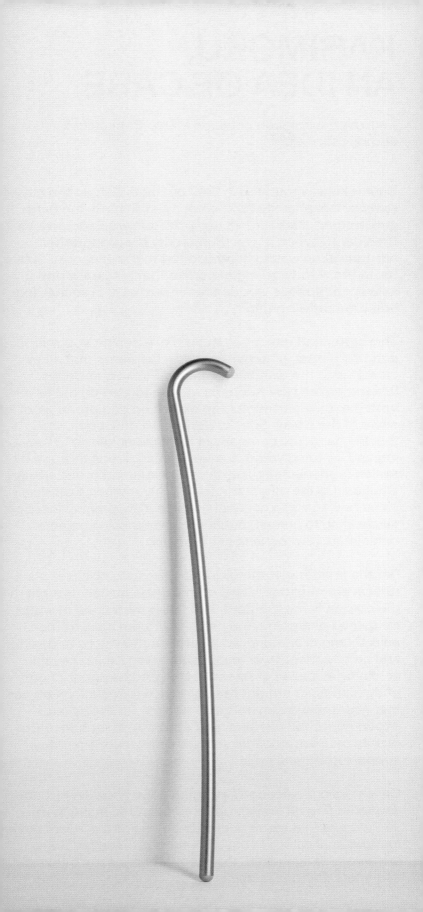

KARIMOKU, AN IDEA OF CARE

From a conversation between Marco Sammicheli and Hiroshi Kato

Karimoku was founded in 1940 by Shoei Kato in the city of Kariya. "It is a family-run company, and this is the third generation," says Hiroshi Kato, the current Executive Vice President. "When it was founded by my grandfather, his motivation was to bring comfort to the Japanese public, using the woodworking expertise that his family possessed to produce wooden furniture that is practical, functional and offers relief."

This statement describes Karimoku's design approach, and its interest in human beings – elements that align closely with the exhibition *Walking Sticks and Canes*. It summarizes why Karimoku chose to participate as both the main partner for the exhibition and producer of some of the walking sticks depicted in this book. On the one hand, the company is highly specialized in treating and bending wood to meet human needs through skilled craftsmanship, production experience, and design intuition. On the other hand, it has the acumen to understand how the idea connects design to its primary function: responding to human requirements and using objects to facilitate new behaviors in society.

For the first time, Karimoku has chosen to sponsor a cultural event outside of Japan. This decision has brought the company into contact with five generations of world-renowned designers and has led it to the halls of Triennale Milano, a century-old institution dedicated to design and architecture. Most importantly, it led Keiji Takeuchi, in his triple role as creator, curator, and designer of one of the canes, to prompt the designers to rethink an object that needed to be revitalized – not just for the sake of experimentation but also, and above all, to enhance the dignity of users who rely on such objects for everyday support while walking.

Considering the needs of an aging population living longer and reflecting on how to update objects to make them useful tools that express dignity and a spirit of service are foundational values in the designer's profession. These are also urgent matters that garner consensus between designers and businesses.

Karimoku's decision to embrace Takeuchi's project was driven by a desire to encourage collaboration beyond cultural and national differences. "Learning from others through collaborative projects like this is an example," says Kato. "For this, I thank Keiji."

The shared sense of purpose, the thrill of the challenge, alignment with company values, the curiosity to engage with something new, and the fortunate coincidence of a meeting among professionals are the ingredients of a story that adds a sense of community to a company's patronage. This narrative seeks to reignite the debate on a topic that has been forgotten, whether due to its lack of economic relevance or because it falls outside more pressing concerns: what could be more important than caring for others?

Keiji Takeuchi was born in Japan and raised in New Zealand. He is now based in Italy, where he runs his design office in Milan. Before establishing his firm in 2015, he studied in Auckland and Paris and worked in Tokyo for the designer Naoto Fukasawa. Takeuchi has created furniture and products for international brands, including Italy's Alessi, De Padova, and Living Divani, Millerknoll in the US, NINE in the UK, Fredericia in Denmark, and Karimoku and aru in Japan. He has won several internationally renowned design awards, including the Monocle Design Award, the Archiproduct Design Award, and the EDIDA Japan Award. During the Milan Design Week 2024, he orchestrated the "Walking Sticks & Canes" exhibition at Triennale Milano. It was Takeuchi's first curated show. *Walking Sticks* is his first publication.

Marco Sammicheli is curator of the design, fashion, and crafts sector at Triennale Milano and Director of Museo del Design Italiano. As supervisor of the International Exhibition program, he has been the institutional representative of Triennale at the Bureau International des Expositions in Paris since 2018. He curated exhibitions for museums and galleries on different designers: Estùdio Campana (Power Station of Art, Shanghai); Bruno Munari (Museo del Novecento, Milan); Carlo Mollino, Ettore Sottsass, Alberto Meda, Mario Bellini, Inga Sempé (Triennale Milano). He has written monographs and contributed to several publications on design He teaches at the Catholic University in Milan where he leads a research unit on sacred design in collaboration with the Vatican Museums.

Acknowledgements

Thanks to all the designers, photographers, and everyone who has been involved in this project. Our special thanks go to Hiroshi Katoh, Eiichiroh Katoh, the team at Karimoku, Keiji Takeuchi Design Office, Lorenzo Waller, Francesca Donadoni, Stefano Boeri and Carla Morogallo from Triennale Milano, and Maria Walter Nielsen.

Clarinet in form of a walking stick
Ulrich Ammann
Sissenburg, Switzerland
1800

Walking Sticks

Editors: Keiji Takeuchi and
Marco Sammicheli
With texts by: Anker Bak, Maddalena
Casadei, Michel Charlot, Pierre
Charpin, Henri Frachon, Chris Liljenberg
Halstrøm, Marialaura Irvine, Ville Kokkonen,
Wataru Kumano, Alban Le Henry,
Cecilie Manz, Alberto Meda, Jasper
Morrison, Hugo Passos, Julien Renault,
Julie Richoz, Marco Sammicheli,
Keiji Takeuchi, Jun Yasumoto
Translations (IT–EN): Charlotte Hosmer
Copyediting and proofreading:
George MacBeth
Project coordination: Emilia Maier
Design: Integral Lars Müller
Lithography: prints professional, Berlin,
Germany
Printing and binding: Printer Trento s.r.l,
Trento, Italy
Paper: Munken Kristall Rough, 120g/m²

Lars Müller Publishers
Zurich, Switzerland
www.lars-mueller-publishers.com

ISBN 978-3-03778-778-6

Distributed in North America, Latin America
and the Caribbean by ARTBOOK | D.A.P.
www.artbook.com

Printed in Italy

Image Credits and Sources

4–7: Delfino Sisto Legani
8 (top): © Roy Export Company Ltd.
8 (bottom): Adobe Stock
10 (top): © Rik Trottier/
Dreamstime.com
10 (bottom): Universal Images
Group/Getty Images
14 (top): Japan Forward, sourced
from: https://japan-forward.com/
meet-the-reiwa-emperor-naruhito-
037/
14 (bottom): Robert Lehmann/
imageBROKER.com GmbH & Co.
KG/Alamy Stock Photo
16 (top): Franco Origlia/Getty
Images
16 (bottom): Michal Sikorski/Alamy
Stock Photo
17 (top): Athletics Australia,
sourced from:
https://www.athleticswest.com.
au/news/2024-paris-olympic-
games-recap
17 (bottom): Tim Per Brunsgård
18 (top): © Walter Carone/
Paris Match/Scoop
18 (bottom): Goldecker GmbH/
www.kunstbeziehung.de
25, 27, 29, 31, 33, 35, 37, 39, 41, 43,
45, 47, 49, 51, 53, 55, 57, 59: Miro
Zagnoli
63: © C. Darbelet/Vichy Enchères

We have made every effort to
identify all rightsholders. Should
despite our intensive research
any person entitled to rights have
been overlooked, they are
kindly requested to contact the
publisher.